Draw
Flowers &
Plants

KT-494-214

MARY SEYMOUR

Series editors: David and Brenda Herbert

A & C Black • London

First published in 1981
New style of paperback binding 1997
By A&C Black Publishers Limited
38 Soho Square, London W1D 3HB
www.acblack.com

Reprinted 1999, 2004, 2007

ISBN-10: 0-7136-8308-2
ISBN-13: 978-0-7136-8308-0

© 1980 A&C Black Publishers Limited

All rights reserved. No part of this publication
may be reproduced, stored in a retrieval system,
or transmitted, in any form or by any means, electronic,
mechanical, photocopying, recording or otherwise,
without the prior permission in writing of
A&C Black Publishers Limited.

Cover design by Emily Bornoff

Printed in China by WKT Company Limited

This book is produced using paper that is made from
wood grown in managed, sustainable forests. It is natural,
renewable and recyclable. The logging and manufacturing
processes conform to the environmental regulations
of the country of origin.

Contents

Making a start

Learning to draw is largely a matter of practice and observation—so draw as much and as often as you can, and use your eyes all the time.

Look around you—at chairs, tables, plants, people, pets, buildings, your hand holding this book. Everything is worth drawing. The time you spend on a drawing is not important. A ten-minute sketch can say more than a slow, painstaking drawing that takes many hours.

Carry a sketchbook with you whenever possible, and don't be shy of using it in public, either for quick notes to be used later or for a finished drawing.

To do an interesting drawing, you must enjoy it. Even if you start on something that doesn't particularly interest you, you will probably find that the act of drawing it—and looking at it in a new way—creates its own excitement. The less you think about how you are drawing and the more you think about what you are drawing, the better your drawing will be.

The best equipment will not itself make you a better artist—a masterpiece can be drawn with a stump of pencil on a scrap of paper. But good equipment is encouraging and pleasant to use, so buy the best you can afford and don't be afraid to use it freely.

Be as bold as you dare. It's your piece of paper and you can do what you like with it. Experiment with the biggest piece of paper and the boldest, softest piece of chalk or crayon you can find, filling the paper with lines to get a feeling of freedom. Even if you think you have a gift for tiny delicate line drawings with a fine pen or pencil, this is worth trying. It will act as a 'loosening up' exercise. The results may surprise you.

Be self-critical. If a drawing looks wrong, scrap it and start again. A second, third or even fourth attempt will often be better than the first, because you are learning more about the subject all the time. Use an eraser as little as possible—piecemeal correction won't help. Don't re-trace your lines. If a line is right the first time, leave it alone— heavier re-drawing leads to a dull, mechanical look.

Try drawing in colour. Dark blue, reddish-brown and dark green are good drawing colours. A coloured pencil, pen or chalk can often be very useful for detail, emphasis or contrast on a black and white drawing.

You can learn a certain amount from copying other people's drawings. But you will learn more from a drawing done from direct observation

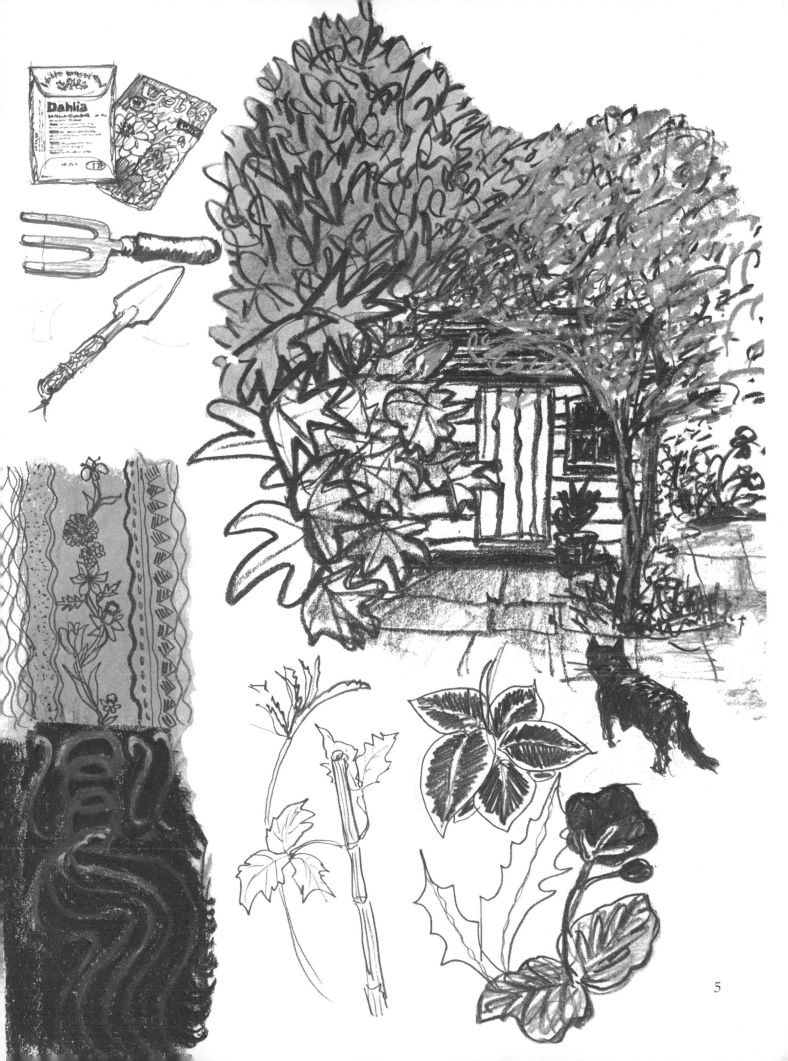

of the subject or even out of your head, however stiff and unsatisfactory the results may seem at first. When copying you are only reinterpreting someone else's interpretation of the subject. It may be useful occasionally to help you understand the technique, but otherwise, draw direct from your object whenever possible.

A lot can be learned by practice and from books, but a teacher can be a great help. If you get the chance, don't hesitate to join a class—even one evening a week can do a lot of good.

Try whatever sort of drawing you enjoy—bold charcoal drawings as on the previous page or more delicate sketches just picking out the parts of the subject that interest you, as on these pages.

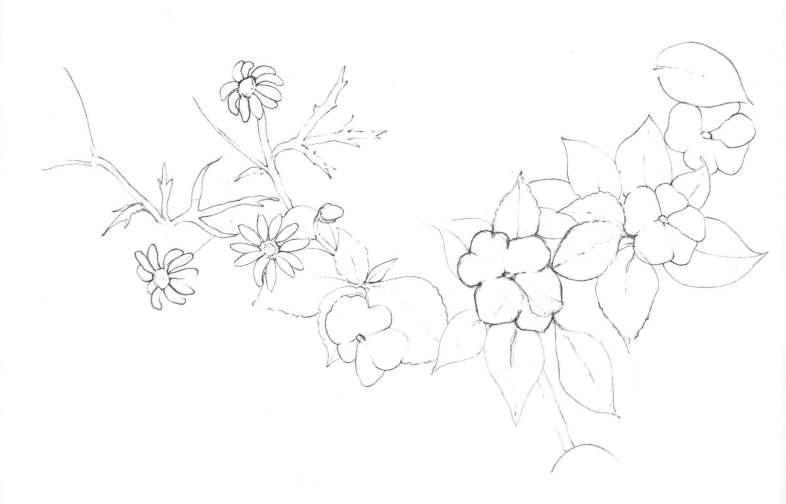

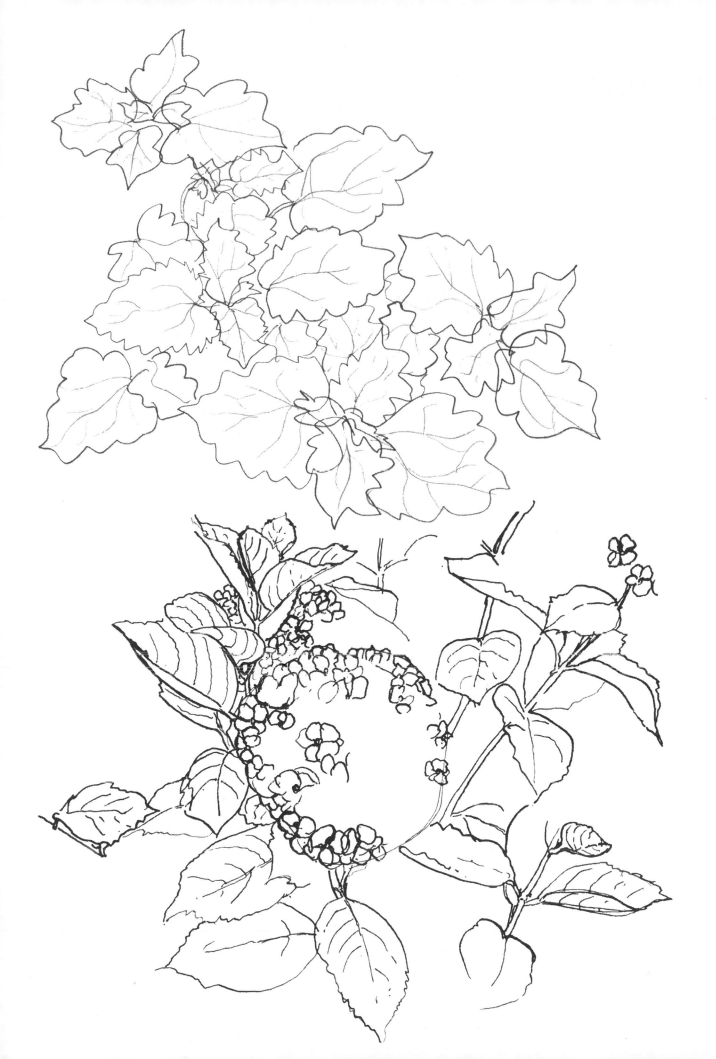

Where to find your subject

If you have a garden, that is the most obvious place to start drawing plants and flowers. If you don't, you could start with pot plants, either your own or borrowed from friends or go for a walk with your sketchbook across a field, draw a hedgerow, or go to your local park. A camping stool would be useful.

Try drawing flowers in balcony boxes, or even weeds. Any plant can be interesting to draw.

Plants thrive in derelict areas or along railway banks where people don't usually bother to go.

Draw on scraps of paper, backs of envelopes or, better still, take a sketchbook with you, small enough to fit in your handbag or pocket, whenever you go out.

Park bench, if you don't mind company

Derelict wasteland

Railway bank — when the train stops

Flower shop window

8

Garden in the centre of a city

What to draw with

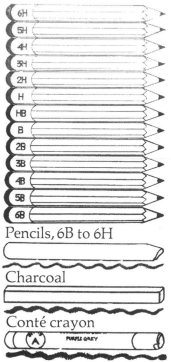

Pencils, 6B to 6H

Charcoal

Conté crayon

Pastel
Brush, biro, fountain pen,
felt tip, Rotring,
Gillot 303, mapping pen

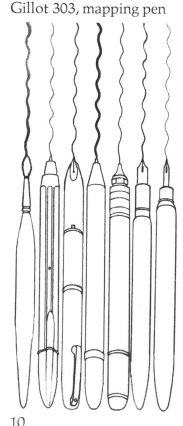

Pencils are graded according to hardness, from 6H (the hardest) through 5H, 4H, 3H, 2H to H; then HB; then B, through 1B, 2B, 3B, 4B, 5B up to 6B (the softest). For most purposes, a soft pencil (HB or softer) is best. If you keep it sharp, it will draw as fine a line as a hard pencil but with less pressure, which makes it easier to control. Sometimes it is effective to smudge the line with your finger or an eraser, but if you do this too much the drawing will look woolly. A fine range of graphite drawing pencils is Royal Sovereign.

Charcoal (which is very soft) is excellent for large, bold sketches, but not for detail. If you use it, beware of accidental smudging. A drawing can even be dusted or rubbed off the paper altogether. To prevent this, spray with fixative. Charcoal pencils, such as the Royal Sovereign, are also very useful.

Wax crayons (also soft) are not easily smudged or erased. You can scrape a line away from a drawing on good quality paper, or partly scrape a drawing to get a special effect.

Conté crayons, wood-cased or in solid sticks, are available in various degrees of hardness, and in three colours—black, red and white. The cased crayons are easy to sharpen, but the solid sticks are more fun— you can use the side of the stick for large areas of tone. Conté is harder than charcoal, but it is also easy to smudge. The black is very intense.

Pastels (available in a wide range of colours) are softer still. Since drawings in pastel are usually called 'paintings', they are really beyond the scope of this book.

Pens vary as much as pencils or crayons. The Gillott 659 is a very popular crowquill pen. Ink has a quality of its own, but of course it cannot be erased. Mapping pens are only suitable for delicate detail and minute cross-hatching.
Special artists' pens, such as the Gillot 303, or the Gillott 404, allow you a more varied line, according to the angle at which you hold them and the pressure you use.

Reed, bamboo and quill pens are good for bold lines and you can make the nib end narrower or wider with the help of a sharp knife or razor blade. This kind of pen has to be dipped frequently into the ink.

Fountain pens have a softer touch than dip-in pens, and many artists prefer them. The portability of the fountain pen, makes it a very useful sketching tool.

Special fountain pens, such as Rapidograph and Rotring, control the flow of ink by means of a needle valve in a fine tube (the nib). Nibs are available in several grades of fineness and are interchangeable. The line they produce is of unvarying thickness, but on coarse paper you can draw an interesting broken line similar to that of a crayon. These pens have to held at a right-angle to the paper, which is a disadvantage.

Inks also vary. Waterproof Indian ink quickly clogs the pen. Pelikan Fount India (UK Pelikan Fountink), which is nearly as black, flows more smoothly and does not leave a varnishy deposit on the pen. Ordinary fountain-pen or writing inks (black, blue, green or brown) are less opaque, so give a drawing more variety of tone. You can mix water with any ink in order to make it thinner. But if you are using Indian ink, add distilled or rain water, because ordinary water will cause it to curdle.

Ball point pens make a drawing look a bit mechanical, but they are cheap and fool-proof and useful for quick notes and scribbles.

Fibre pens are only slightly better, and their points tend to wear down quickly.

Felt pens are useful for quick notes and sketches, but are not good for more elaborate and finished drawings.

Brushes are most versatile drawing instruments. The Chinese and Japanese know this and until recently never used anything else, even for writing. The biggest sable brush has a fine point, and the smallest brush laid on its side provides a line broader than the broadest nib. You can add depth and variety to a pen or crayon drawing by washing over it with a brush dipped in clean water.

Mixed methods are often pleasing. Try making drawings with pen and pencil, pen and wash or Conté and wash. And try drawing with a pen on wet paper. Pencil and Conté does not look well together and Conté will not draw over pencil or greasy surfaces.

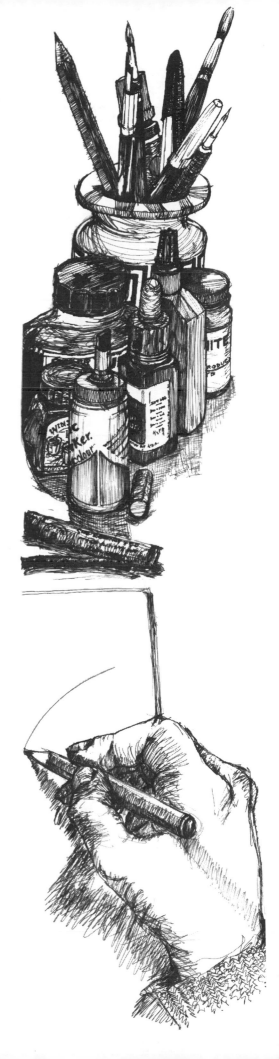

What to draw on

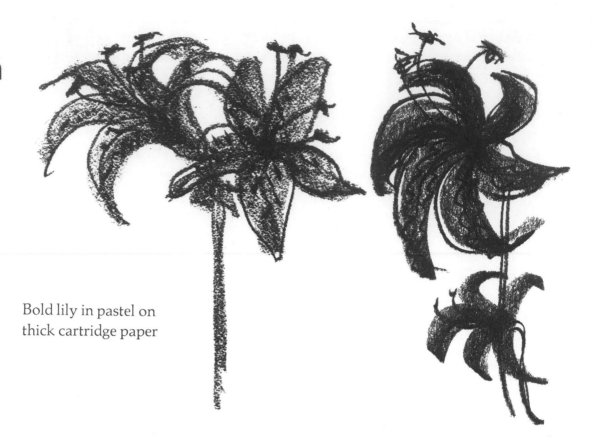

Bold lily in pastel on
thick cartridge paper

Bold lily in pastel on
smooth paper

Try as many different surfaces as possible.

Ordinary, inexpensive paper is often as good as anything else: for
example, brown and buff wrapping paper (Kraft paper) and lining for
wallpaper have surfaces which are particularly suitable for charcoal
and soft crayons. Some writing and duplicating papers are best for pen
drawings. But there are many papers and brands made specially for the
artist.

Bristol board is a smooth, hard white board designed for fine pen work.

Ledger Bond paper ('cartridge' in the UK), the most usual drawing
paper, is available in a variety of surfaces—smooth, 'not surface' (semi-
rough), rough.

Watercolour papers also come in various grades of smoothness. They
are thick, high-quality papers, expensive but pleasant to use.

Ingres paper is mainly for pastel drawings. It has a soft, furry surface
and is made in many light colours—grey, pink, blue, buff, etc.

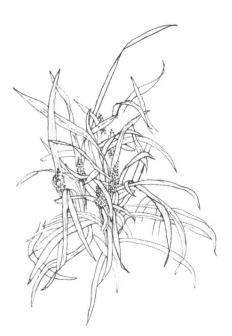

Delicate plant in H pencil
on smooth paper

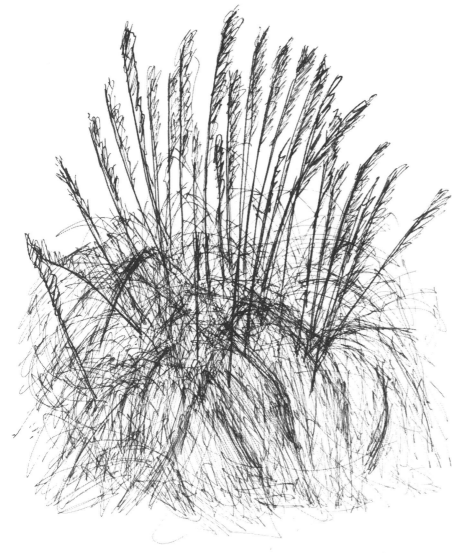

Spindly grass in fountain pen (underside of nib) on smooth paper

Sketchbooks, made up from nearly all these papers, are available. Choose one with thin, smooth paper to begin with. Thin paper means more pages, and smooth surface is best to record detail.

Lay-out pads make useful sketchbooks. Although their covers are not stiff, you can easily insert a stiff piece of card to act as firm backing to your drawing. The paper is semi-transparent, but this can be useful — almost as tracing paper — if you want to make a new, improved version of your last drawing.

An improvised sketchbook can be just as good as a bought one — or better. Find two pieces of thick card, sandwich a stack of paper, preferably of different kinds, between them and clip together at either end.

Try to choose the most suitable drawing instrument and paper for your subject. A heavy bold plant might look better drawn in charcoal. A delicate plant might look better in pencil.

Heavy lupin in charcoal
on ordinary brown wrapping
paper

Looking at detail: 1

Drawing the different parts of flowers and plants can be a useful exercise in observation, and your understanding of how they fit together will be reflected in your drawing.

Ask yourself questions all the time and try making written as well as drawn notes about what you have observed.

Here are some of the things you might look for.

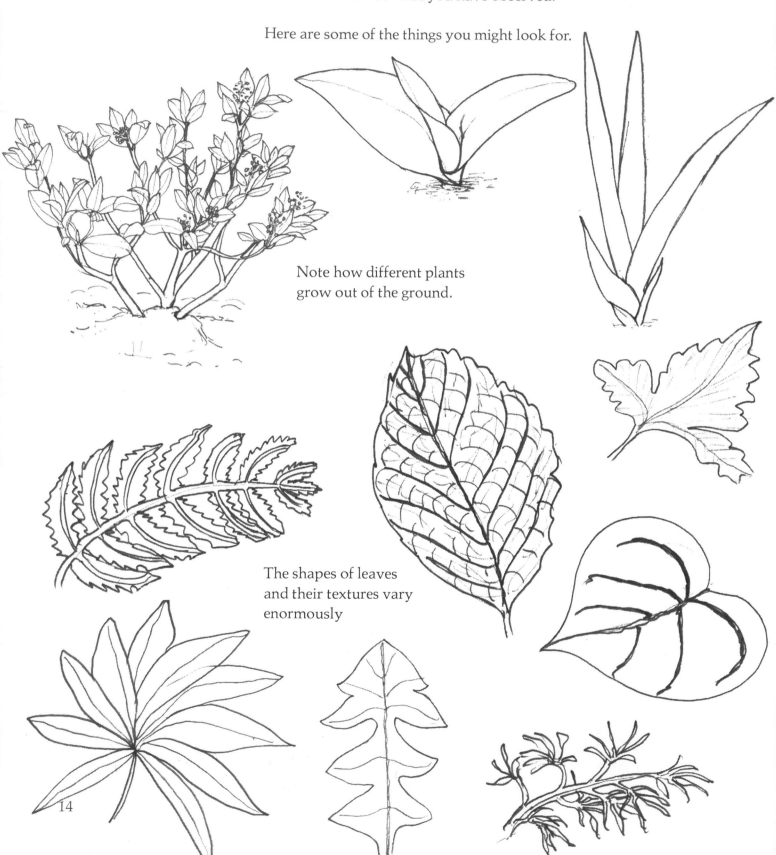

Note how different plants grow out of the ground.

The shapes of leaves and their textures vary enormously

14

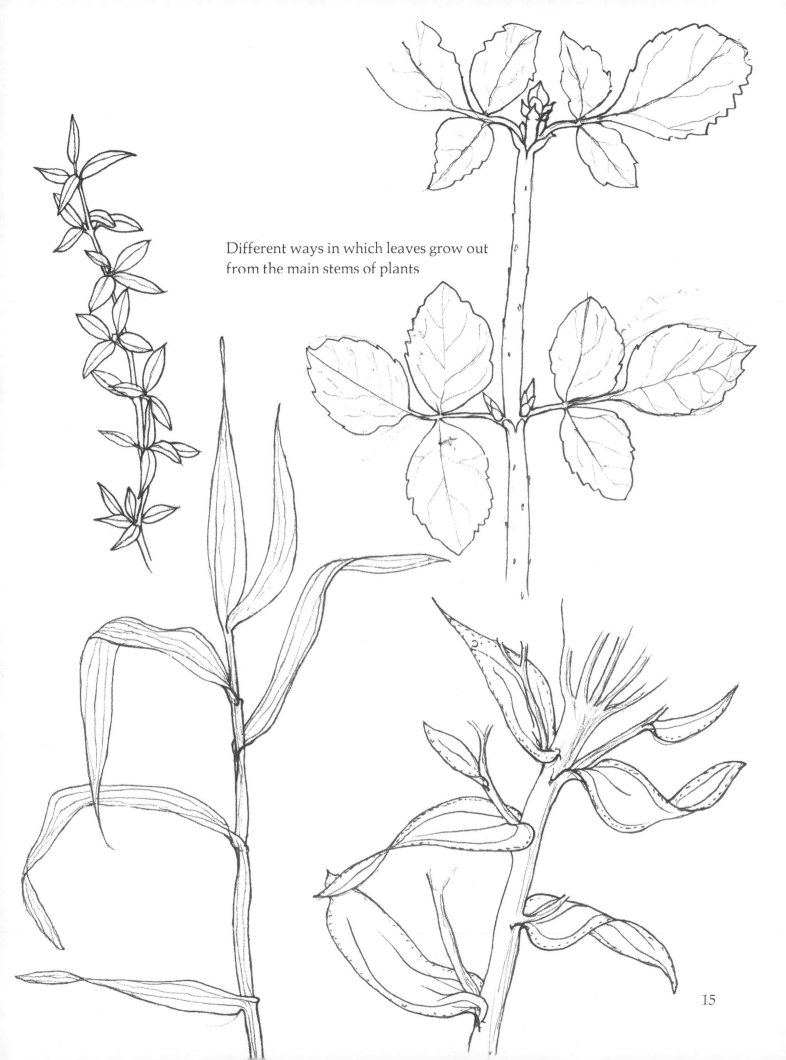

Different ways in which leaves grow out
from the main stems of plants

Looking at detail: 2

On this page the daffodil and tulip are compared as whole plants. On the opposite page the amaryllis lily, daisy and fuchsia are compared to show the way they join their stalks, the grouping of the flowers and the shapes of their petals.

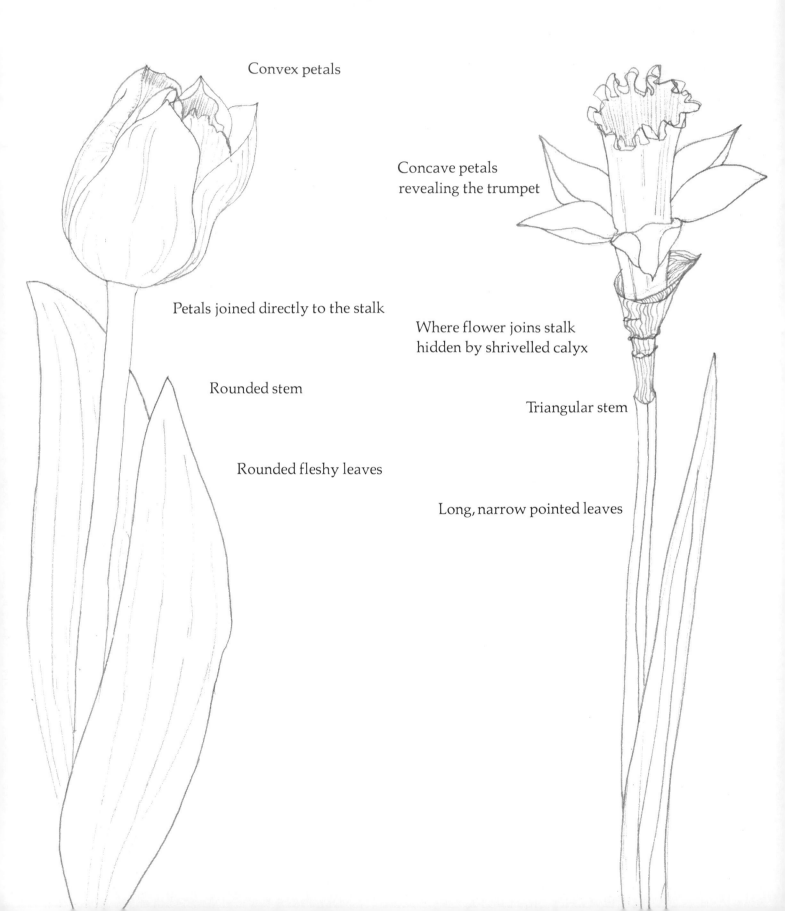

Convex petals

Concave petals revealing the trumpet

Petals joined directly to the stalk

Where flower joins stalk hidden by shrivelled calyx

Rounded stem

Triangular stem

Rounded fleshy leaves

Long, narrow pointed leaves

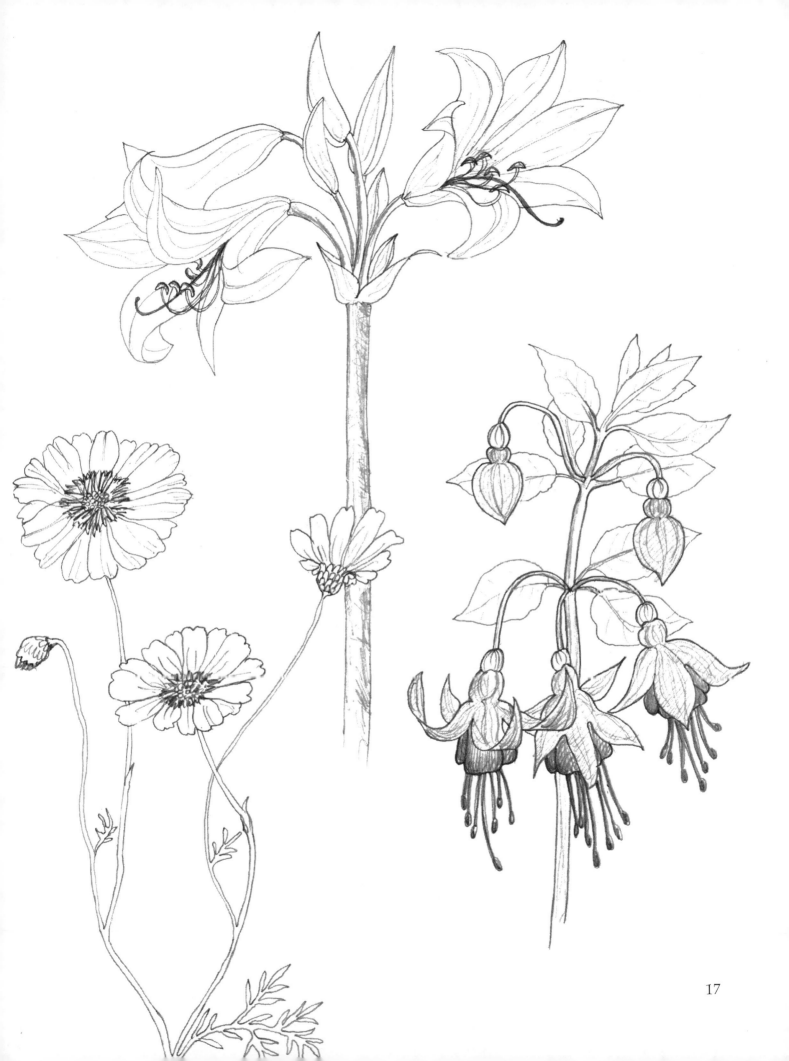

Grasping essentials: 1

Try to decide what is the essential feature of a flower and then select the best aspect of it to draw and the best position to draw it from.

This variety of aster, with its three layers of petals, must be drawn from an angle from which all the layers can be seen. Drawing it head on is not effective.

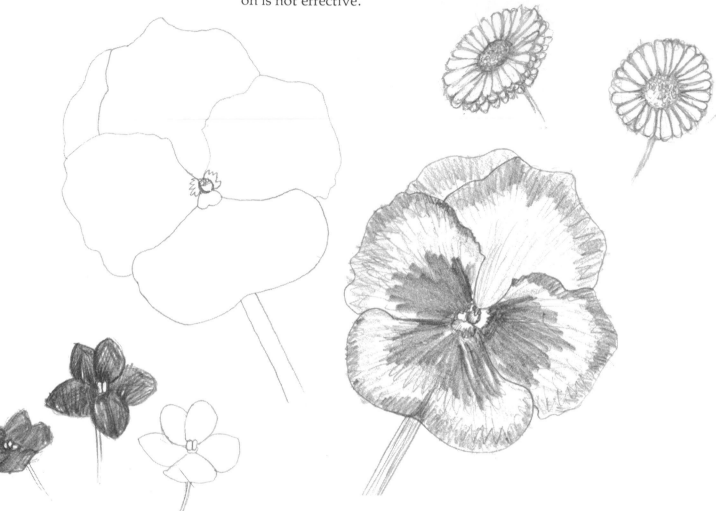

The pansy and African violet are not easy to identify until the colouring and markings are added.

The meadow rue needs to be drawn from several angles to illustrate two facts: the petals curl inwards which is only apparent when the flower is looked at directly; and the stamens protrude beyond the petals, which is only seen from the side.

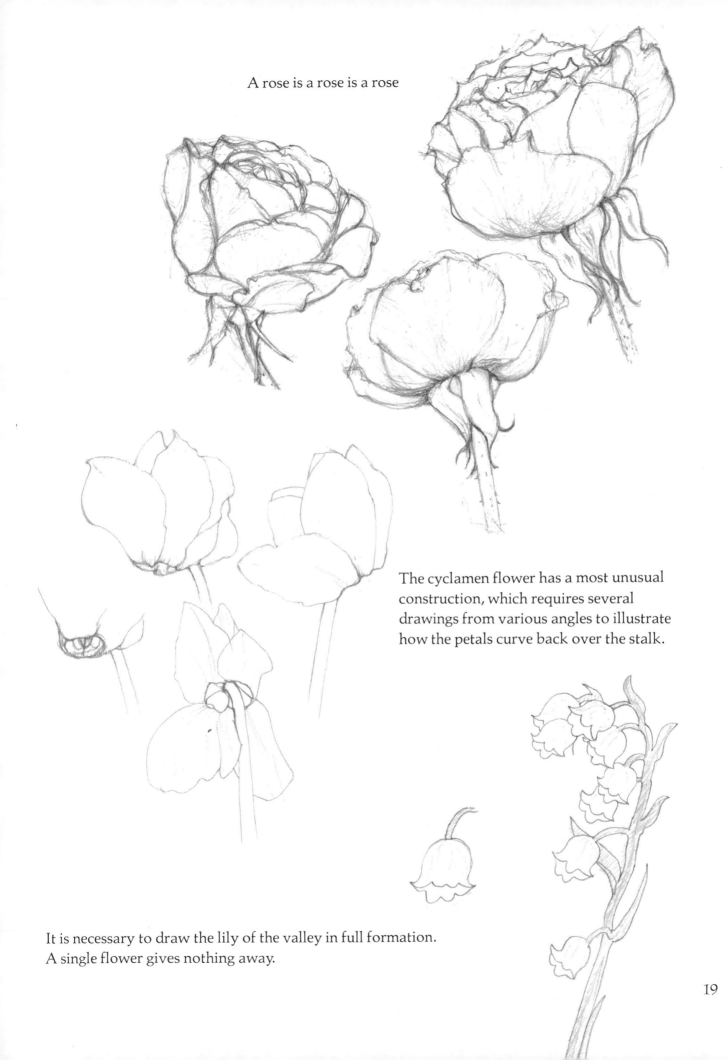

A rose is a rose is a rose

The cyclamen flower has a most unusual construction, which requires several drawings from various angles to illustrate how the petals curve back over the stalk.

It is necessary to draw the lily of the valley in full formation. A single flower gives nothing away.

Grasping essentials: 2 quick sketches

A quick sketch can sometimes tell as much as a highly detailed drawing.

The daffodil has such a distinctive shape that the quickest scribble can indicate its character.

In contrast, the primrose needs to be drawn in great detail, since it is a delicate, multi-featured plant.

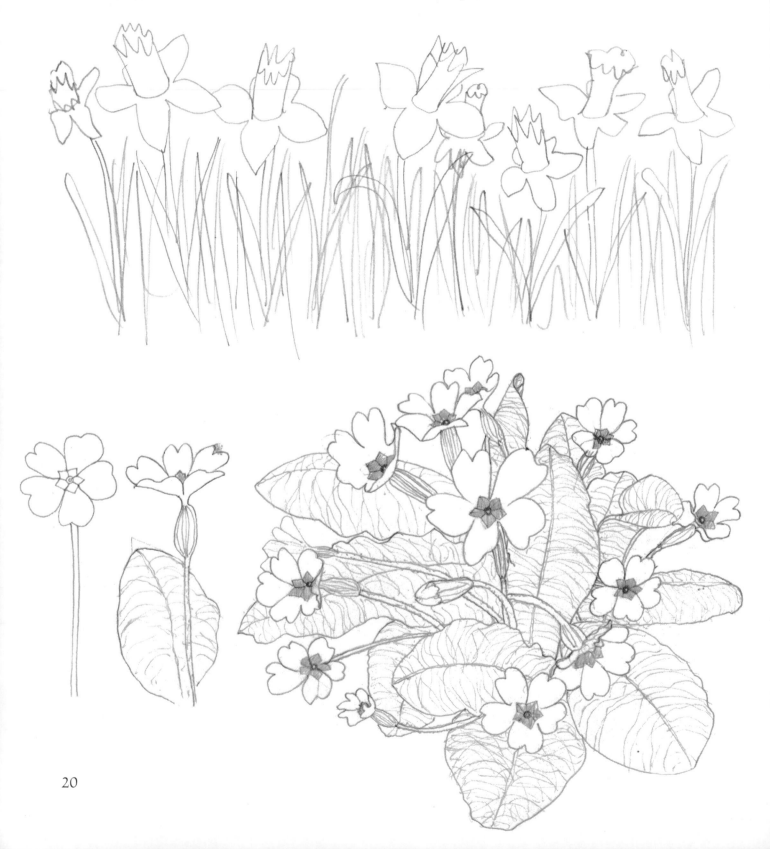

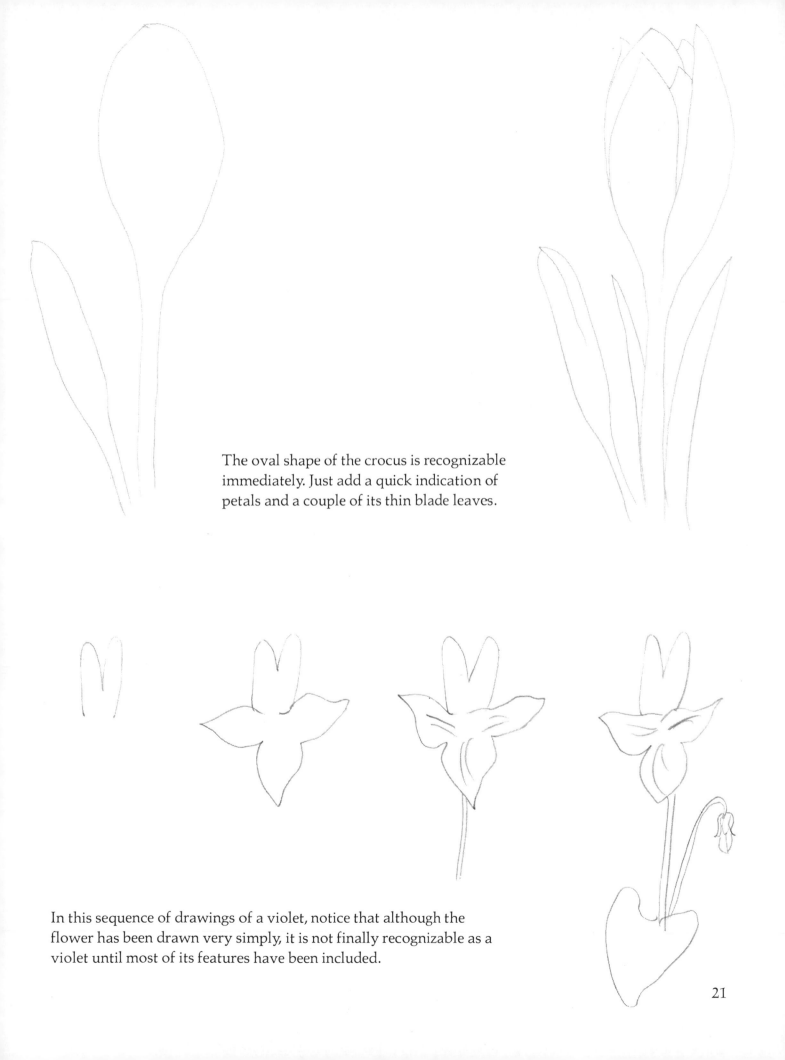

The oval shape of the crocus is recognizable immediately. Just add a quick indication of petals and a couple of its thin blade leaves.

In this sequence of drawings of a violet, notice that although the flower has been drawn very simply, it is not finally recognizable as a violet until most of its features have been included.

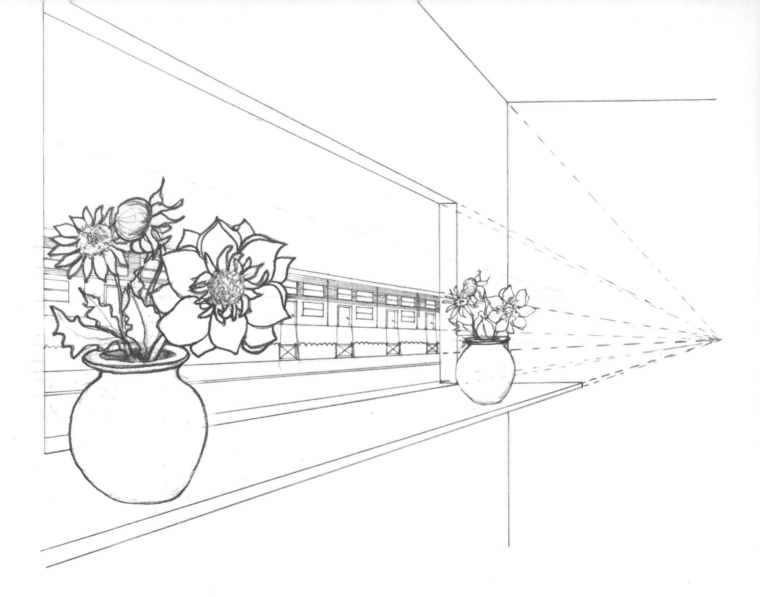

Perspective...

You can be an artist without knowing anything about perspective. Five hundred years ago, when some of the great masterpieces of all time were painted, the word did not even exist. But most beginners want to know something about it in order to make their drawings appear three-dimensional rather than flat, so here is a short guide.

The further away an object is, the smaller it seems.

All parallel horizontal lines that are directly opposite you, at right-angles to your line of vision, remain parallel.

All horizontal lines that are in fact parallel but go away from you, will appear to converge at eye-level at the same vanishing point on the horizon. Lines that are *above* your eye-level will seem to run downwards towards the vanishing point; lines that are *below* your eye-level will run upwards. You can check the angles of these lines against a pencil held horizontally at eye-level.

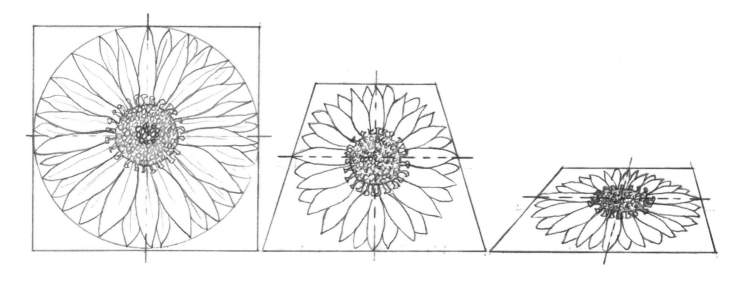

When drawing a circular shape, the following is useful: a square drawn round a circle will touch the circle at the centre point of each of its sides. A foreshortened circle will turn into an oval, but will still touch the centre points of each of a similarly foreshortened square. However distorted the square, the circle will remain a true oval but will seem to tilt as the square moves to left or right of the vanishing point. The same is true of half circles.

One point to mention: all receding parallel lines have the same vanishing point. So if, for instance, you draw a tree-lined street, or a row of flower-beds, this will apply to all the horizontal edges.

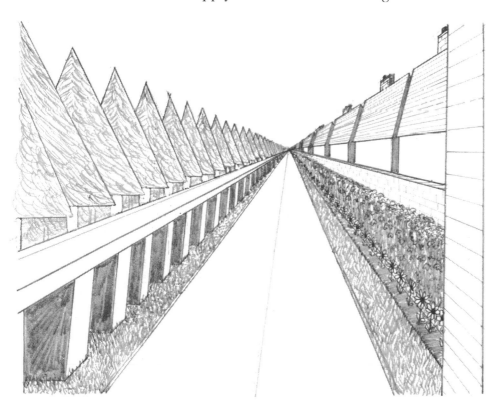

...and fore-shortening

When drawing foreshortened objects, forget what you know and concentrate on what you actually see.

You can check the correct apparent depth of any receding plane by using a pencil or ruler held at eye-level and measuring the proportions on it with your thumb. If you use a ruler you can actually read off the various proportions. Try drawing a leaf against a background that has strong horizontal lines, as I have below, and notice how its apparent shape changes as its plane varies in relation to your viewpoint.

A flower such as a daffodil has several dimensions, not all of which can be seen from every angle. For example, if you look straight at the centre (opposite) you will have no clear idea of its depth.

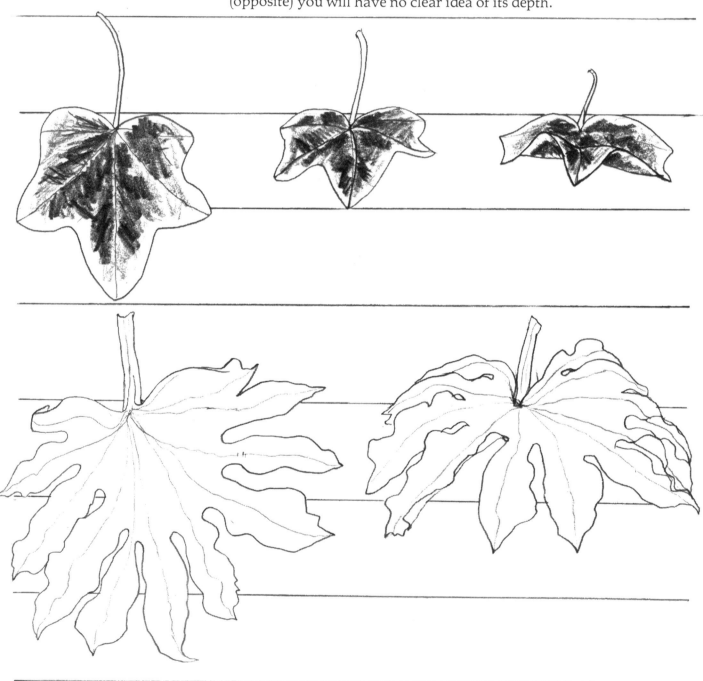

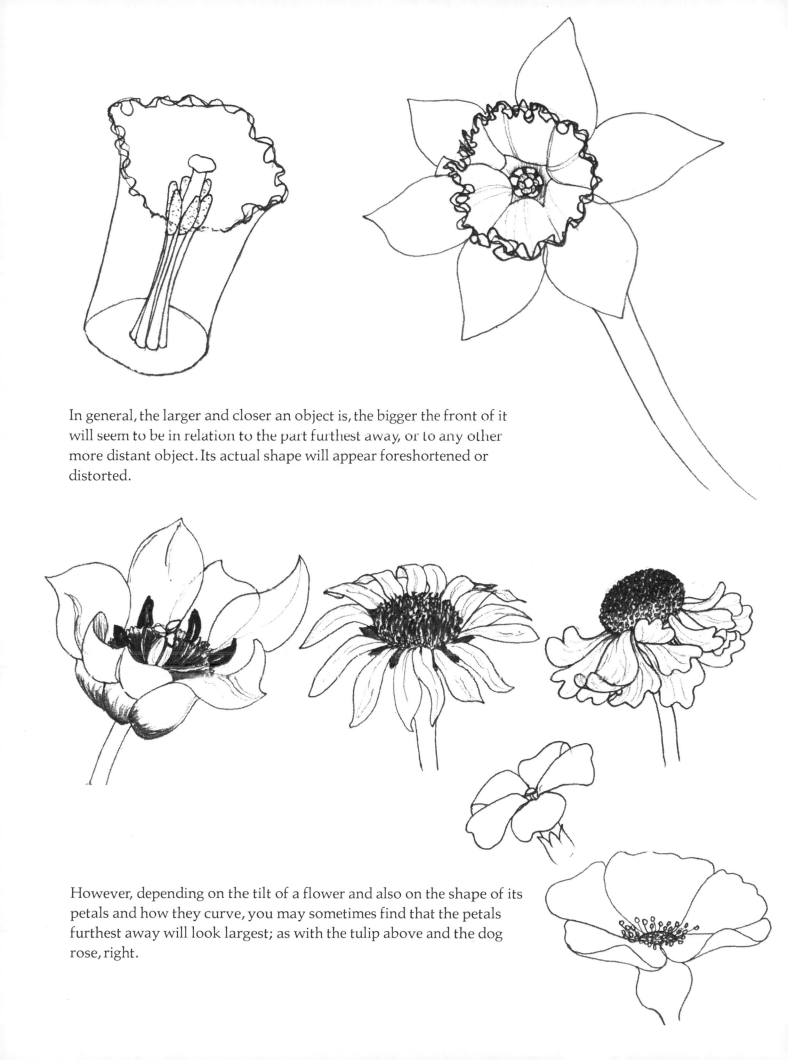

In general, the larger and closer an object is, the bigger the front of it will seem to be in relation to the part furthest away, or to any other more distant object. Its actual shape will appear foreshortened or distorted.

However, depending on the tilt of a flower and also on the shape of its petals and how they curve, you may sometimes find that the petals furthest away will look largest; as with the tulip above and the dog rose, right.

Composition

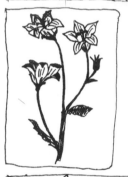

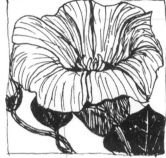

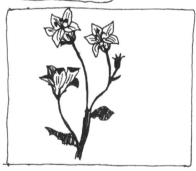

This does not only apply to large, finished paintings. Deciding where to place even the smallest sketch or doodle on a scribbling pad involves composition. The effect of your drawing will be greatly affected by its position on the paper.

It is generally best, when learning to draw, to make your drawing as large as possible on your piece of paper. But there are many possibilities. Sometimes you may not even want the whole of the object on your paper. And there is no reason why the paper should be the same shape as the subject—it is not, for instance, necessary to draw a tall object on an upright piece of paper.

When you are drawing more than one object on a sheet of paper, the placing of each object is also important. Try as many variations as possible.

Before you begin a drawing, think how you will place it on the paper—even a few seconds' thought may save you having to start your drawing again. Never distort your drawing in order to get it all in.

Before starting an elaborate drawing, do a few very rough sketches of the main shapes to help you decide on the final composition.

Rules are made to be broken. Every good artist is a good artist at least partly because of his originality; in fact, because he does what no one else has done before and because he breaks rules.

Every human being is unique. However poor an artist you think you are, you are different from everyone else and your drawing is an expression of your individuality.

Although there can be no general rules about how you do a detailed drawing of a plant or flowers, I have gone step by step through this drawing of a poinsettia, on the next two pages, to show some of the considerations that arose as I drew it.

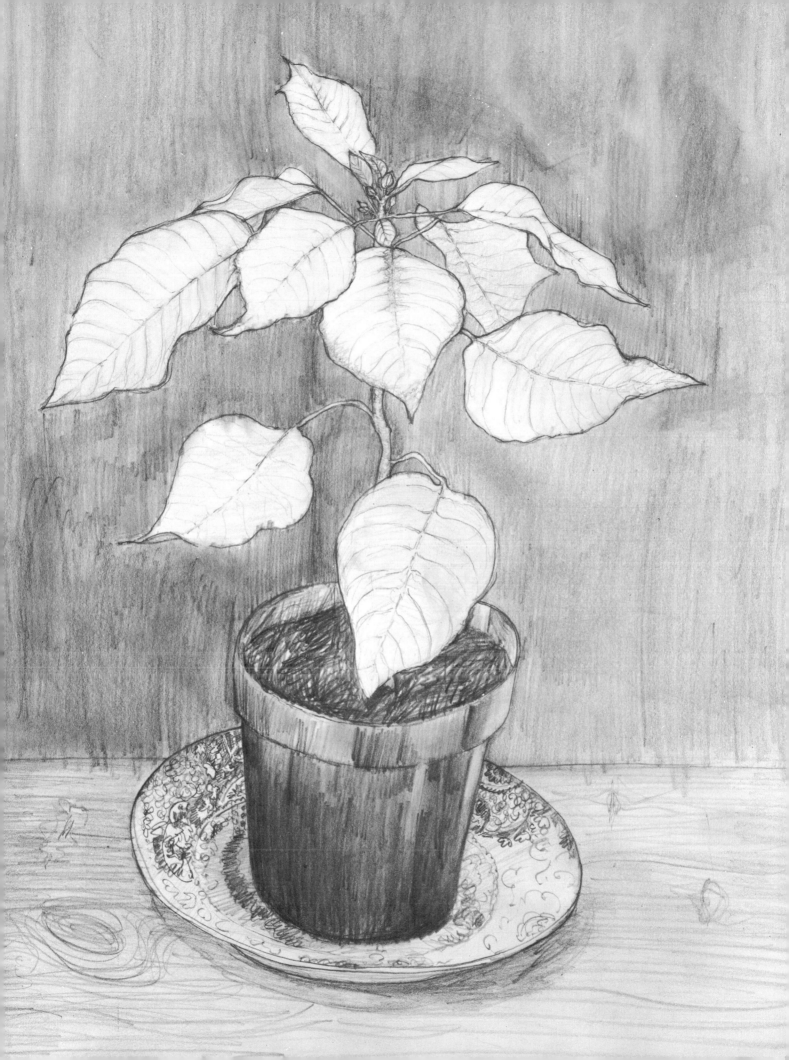

Step by step– a simple pot plant

If the plant is light-coloured and has simple outlines, set it against a dark background, such as a sheet of black card, so that the shapes stand out more clearly.

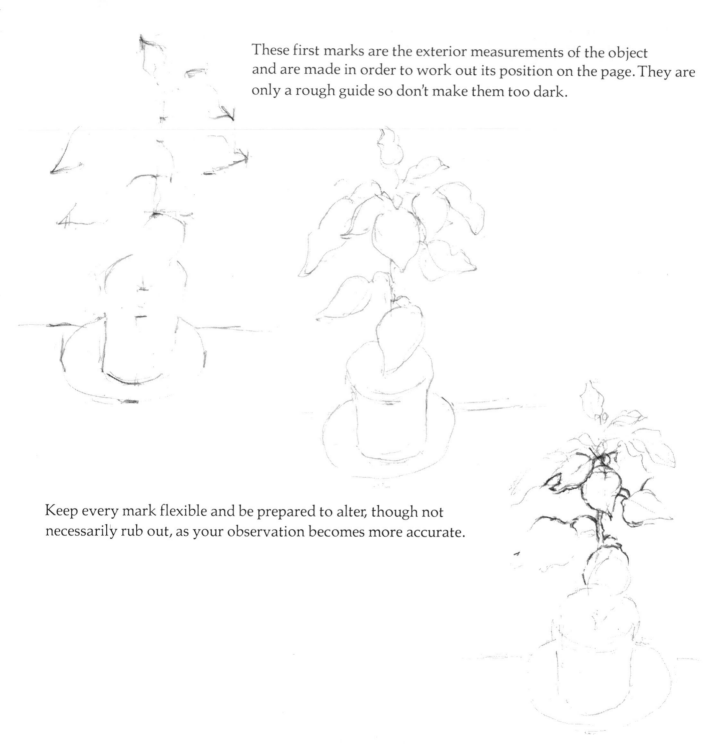

These first marks are the exterior measurements of the object and are made in order to work out its position on the page. They are only a rough guide so don't make them too dark.

Keep every mark flexible and be prepared to alter, though not necessarily rub out, as your observation becomes more accurate.

Notice that in some places I haven't kept to the guidelines. As the study becomes more intense they are seen to be inaccurate.

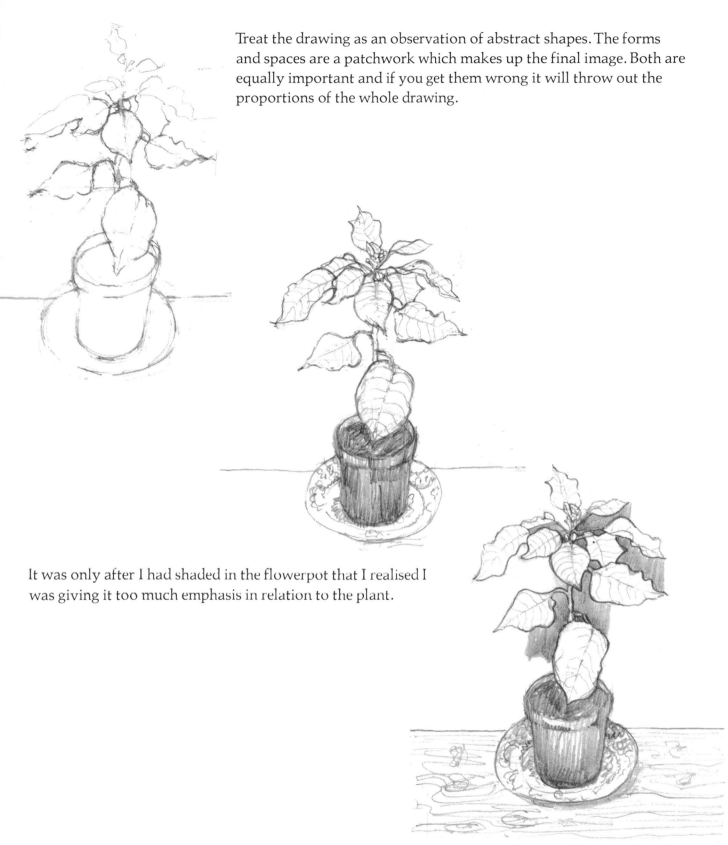

Treat the drawing as an observation of abstract shapes. The forms and spaces are a patchwork which makes up the final image. Both are equally important and if you get them wrong it will throw out the proportions of the whole drawing.

It was only after I had shaded in the flowerpot that I realised I was giving it too much emphasis in relation to the plant.

I therefore shaded everything except the plant to make the paleness of the leaves stand out. I used the pencil all in one direction on its side and then gently used an eraser to give a more even, less distracting background.

Step by step– making sense of a tangle

When drawing a plant with dense foliage, where you can't distinguish all the leaves, and can't therefore draw each one individually, concentrate first on the overall shape of what you are drawing.

Once this has been pencilled in, start being more precise and begin to establish the relationship between one area and another, one major stalk and another.

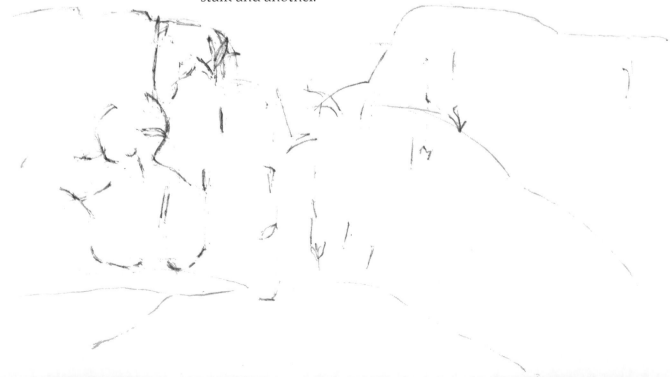

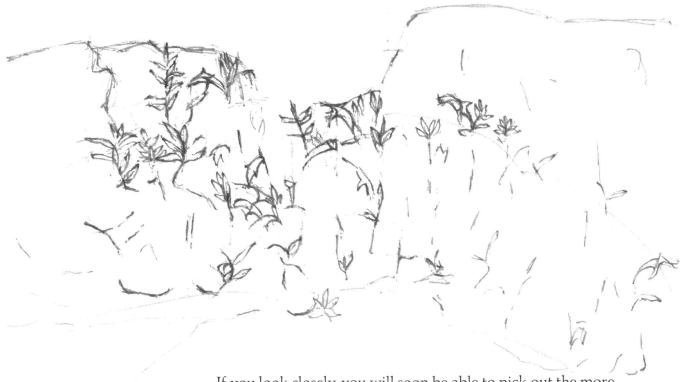

If you look closely, you will soon be able to pick out the more prominent stalks, leaves or flowers from the general mass.

Gradually a pattern is built up in this way and more and more details fall into place until you have a composite picture of what might at first have seemed an impossible tangle of leaves and stalks.

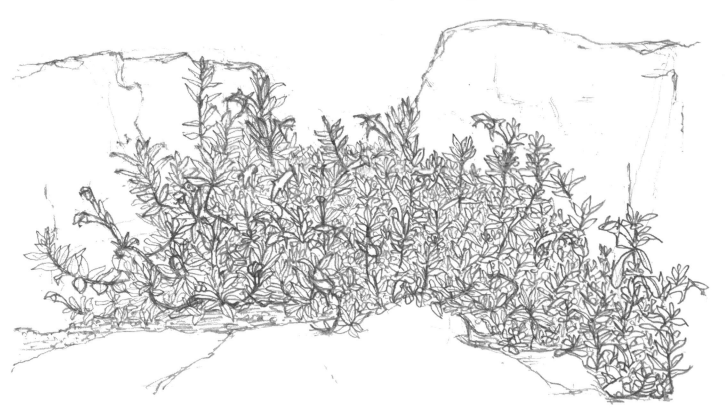

These drawings are of a fairly small rock plant, but you should tackle a large bush in the same way.

Building a drawing: 1 clues all around

A drawing like the one opposite must be built up bit by bit by relating each mark you make to another one, whether adjoining it or across the page.

The sequence of drawings on this page, of a leaf taken from the lower centre of the complete drawing, illustrates how continual reference is made either to another leaf or to the background.

It is easier to relate things horizontally and vertically than to judge the angles of diagonals. On this drawing, the wall and the drainpipe were a great help.

Constant references made in this way will help you to control the drawing and keep it in proportion. However complicated the plant, you can start at one point and simply work outwards in any direction.

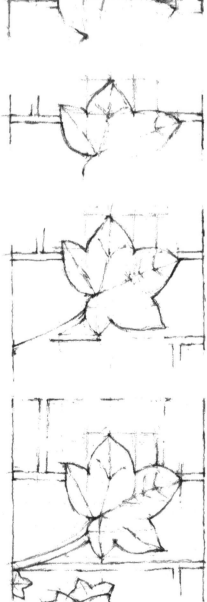

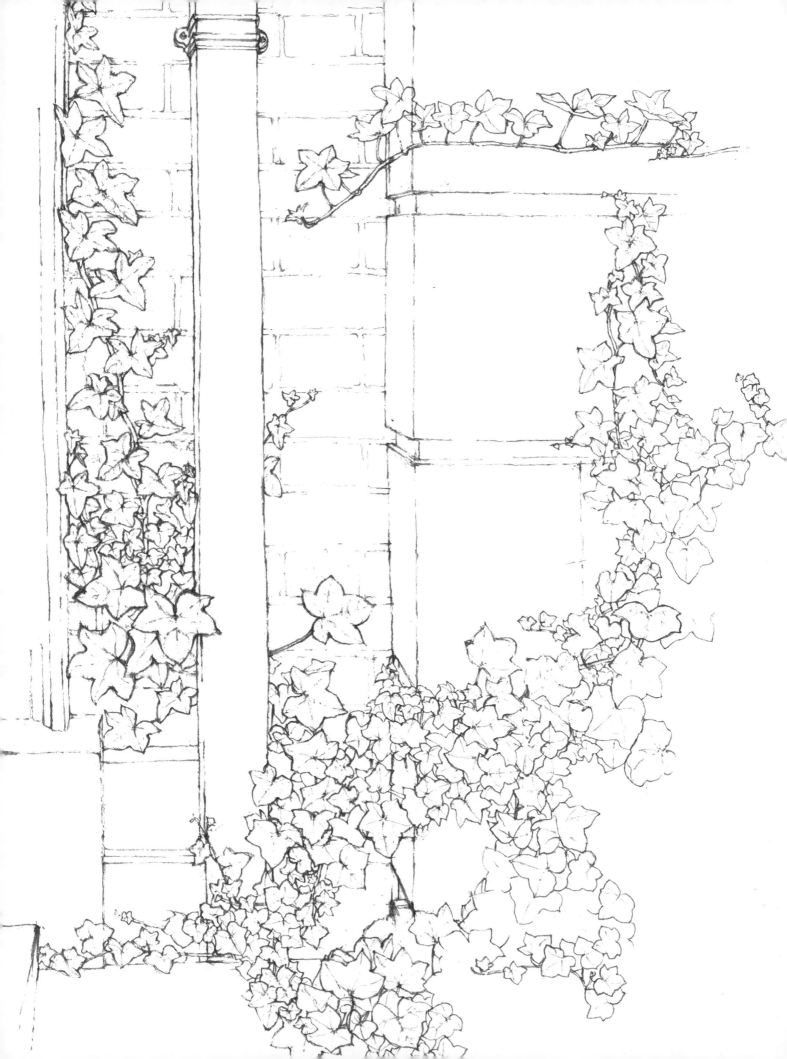

Building a drawing: 2 clues within the plant

The shapes of the leaves and stalks of the plant opposite are very clearly defined, and the way they grow, twisting and falling out of the pot, creates strong shapes between them. These provide enough points of reference within the plant itself for controlling and building up the drawing, and no outside clues are needed.

The vertical and horizontal dotted lines below represent the way my hand and pencil 'feel' across the page when judging distances and relationships.

After a while you will find yourself getting into the rhythm of a drawing. One curve will echo another and a line set at a particular angle will complement a similar one across the page.

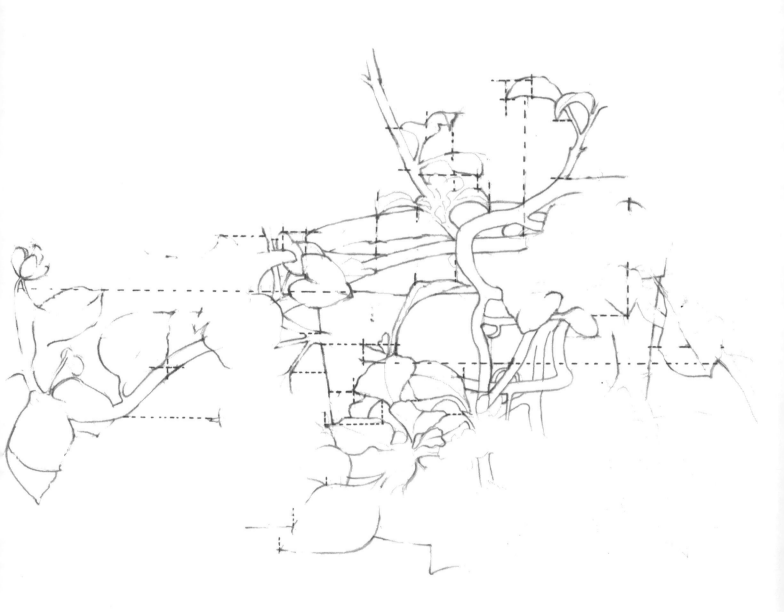

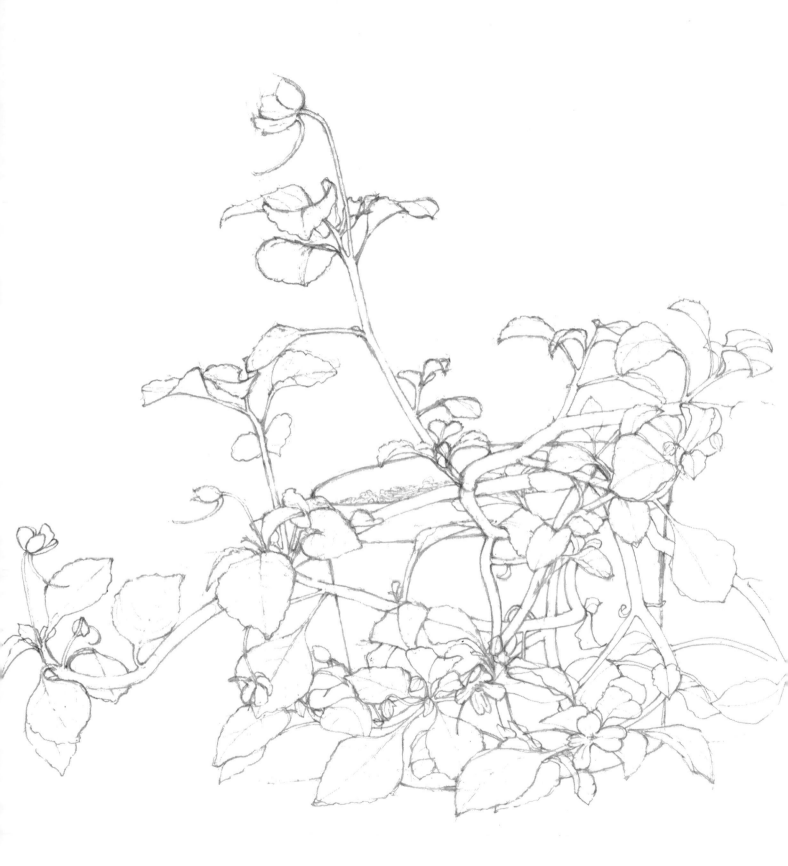

The study of one plant

Take a complicated plant such as an artichoke and have fun seeing how many different angles you can draw it from. After a time you should have a fairly good knowledge of its parts, its characteristics and how it works.

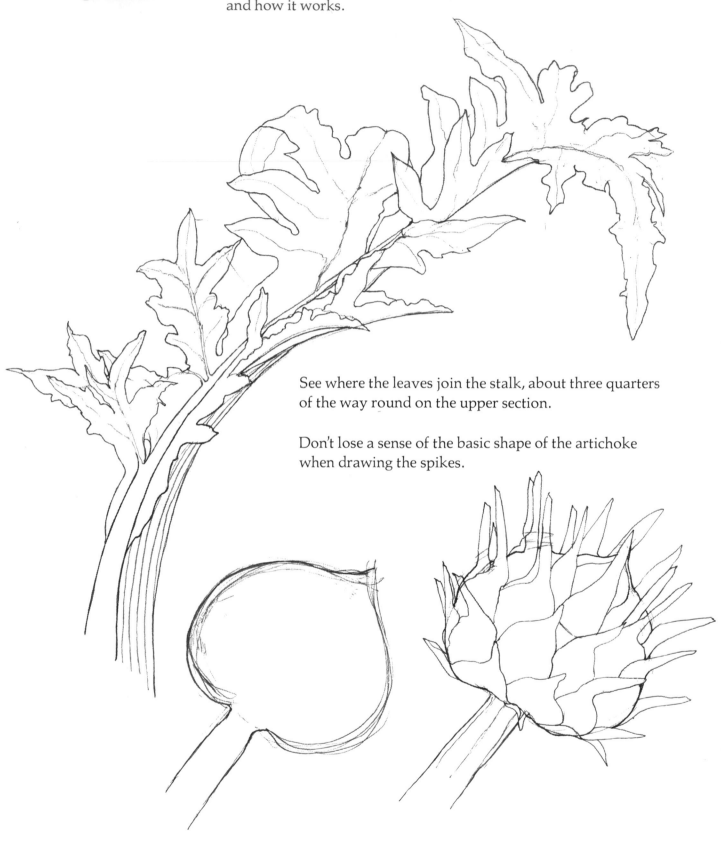

See where the leaves join the stalk, about three quarters of the way round on the upper section.

Don't lose a sense of the basic shape of the artichoke when drawing the spikes.

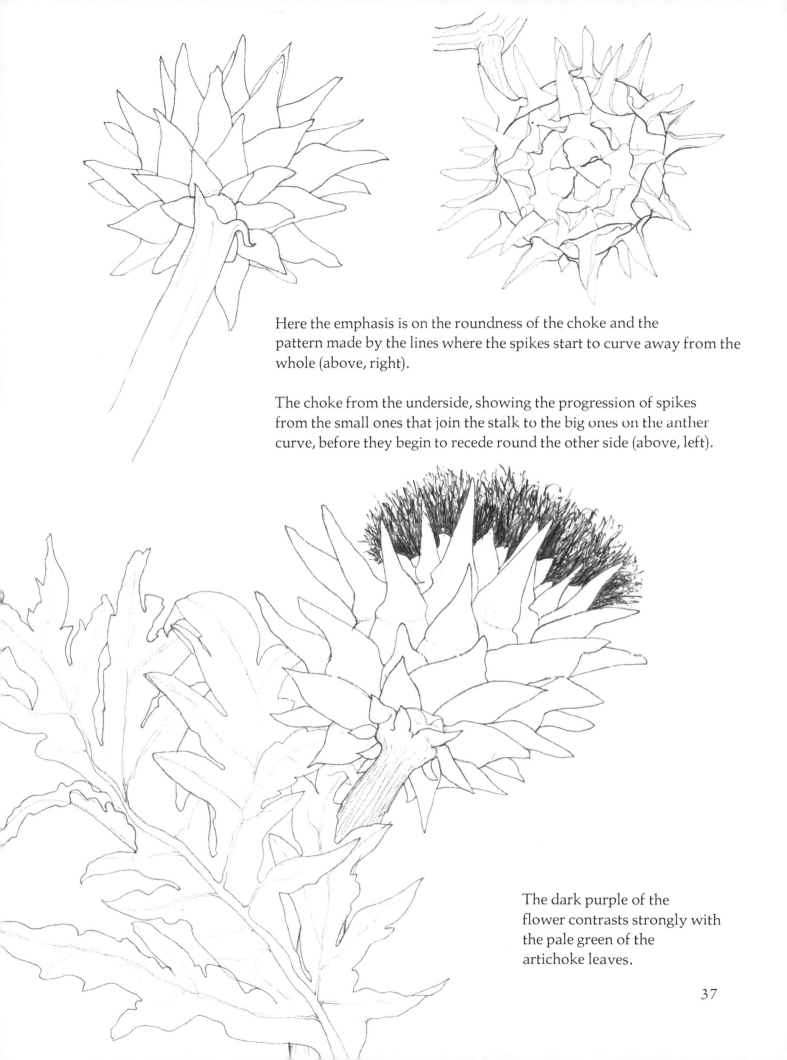

Here the emphasis is on the roundness of the choke and the pattern made by the lines where the spikes start to curve away from the whole (above, right).

The choke from the underside, showing the progression of spikes from the small ones that join the stalk to the big ones on the anther curve, before they begin to recede round the other side (above, left).

The dark purple of the flower contrasts strongly with the pale green of the artichoke leaves.

Light and effect

These sketches show how to convey the overall shape of plants and also the effect of light and shade.

Notice in the drawing below how the leaves are silhouetted in different ways against the background. They appear light against the tangled mass of the main body of the plant and the moss-packed basket, and dark against the sky where they break free in individual tendrils. I have illustrated this point more clearly in the detail.
I used a B pencil for a quick, flowing line and plenty of contrast.
The drawing opposite is of a highly complicated plant (the detail shows one tendril), but here I was concerned only with its overall effect.
The sun shining on the left-hand side of the plant created shadows on the right which helped to define its shape. Bright sunlight on a plant tends to 'burn out' detail.
To get the effect of a mass of stalks I used a controlled 'scribble', and H and HB pencils. As it is a delicate plant I did not want the contrast between light and shade to be too heavily described.

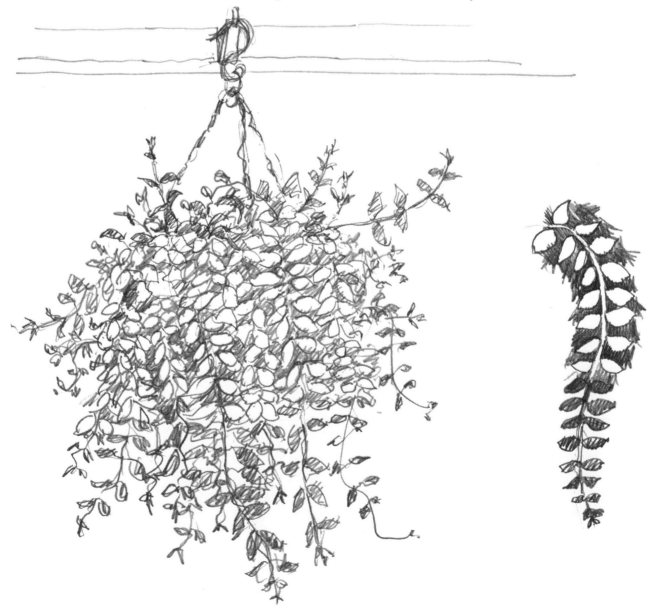

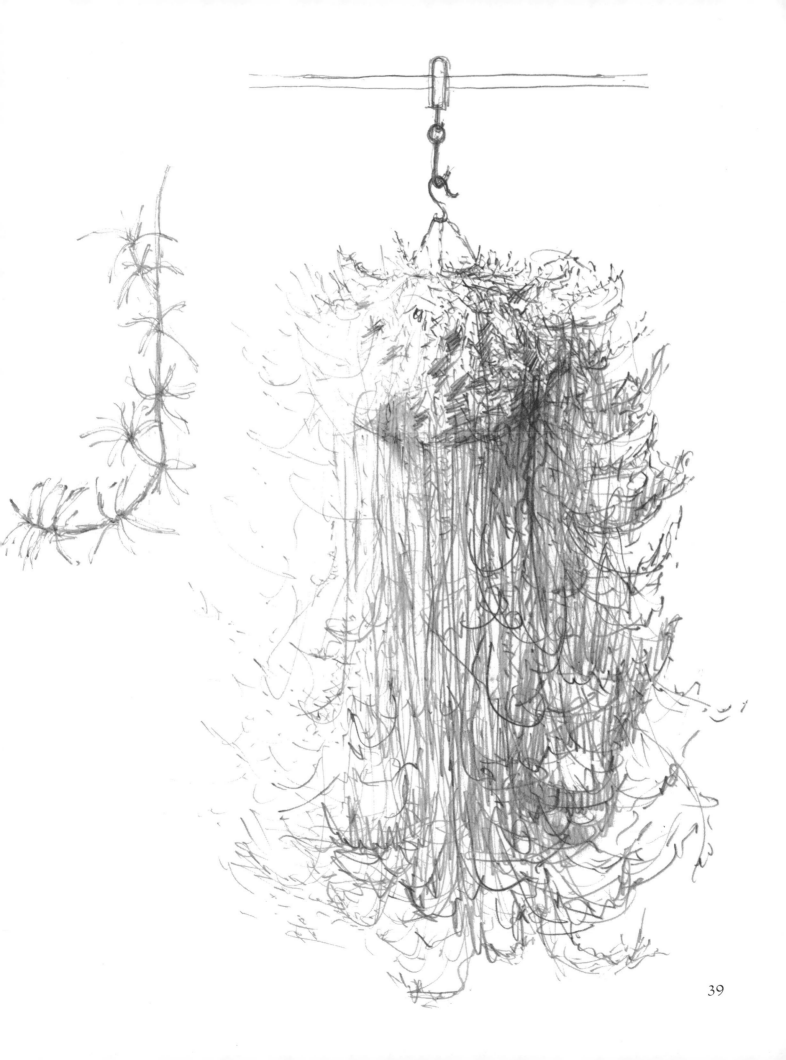

39

A sense of colour in black and white

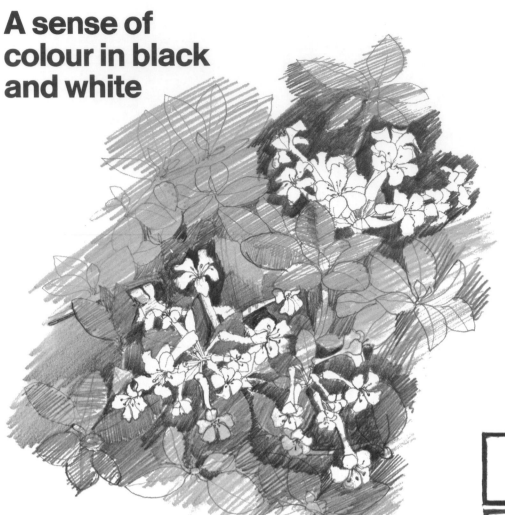

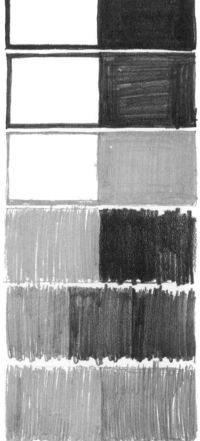

In black and white you can obviously only give an idea of colour, but this can be very effective if you concentrate on tonal contrasts, using dark shading against light in varying degrees of strength.

Practise using different pencils next to each other. In the top three diagrams I have used first a 6B pencil, then HB, then 6H. Notice how much whiter the square next to the darkest 6B pencil appears in comparison with the other two white squares. In the three lower diagrams I have tried different pencils next to each other. An enormous variety of tone can be achieved like this.

To show the whiteness of the rhododendron flowers above, I first did a line drawing of both leaves and flowers and then shaded in everything but the flowers. In contrast to their whiteness, the background immediately behind them appears darker than the surrounding leaves.

The most striking thing about this cineraria is the black centres of the flowers separated by a ruff of white from the dark blue of the petals. To match the character of the plant the drawing was done boldly with fountain pen, using both sides of the nib to vary the thickness of the line, and tone was added with a brush.

When using ink, try diluting it to different strengths.

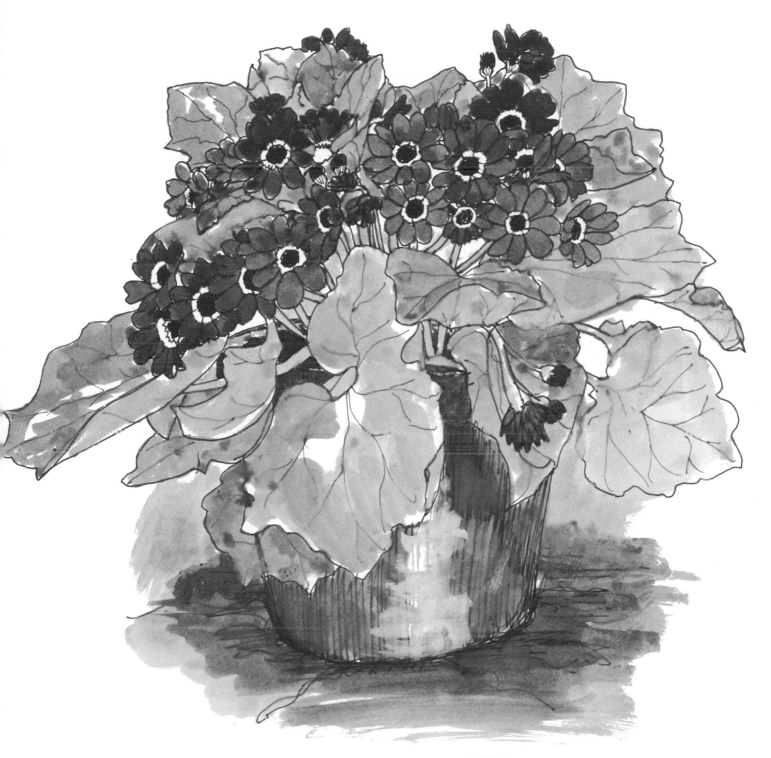

Character and imagination

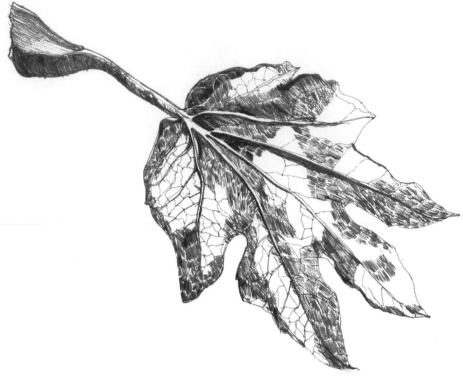

To portray the character of what you are drawing you must learn to be inventive with your drawing medium.

The drawings on this page show a shiny veined leaf and a fleshy, hairy one. Notice how the different textures have been achieved by using short, sharp bold strokes with a pen (above) and thin, spindly, irregular ones (below).

Try, also, drawing lots of different variegated plants. Here, too, you will have to use your imagination and experiment with different media and techniques to get the effect you want.

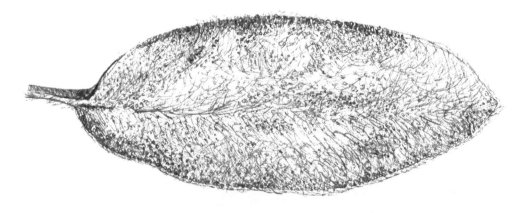

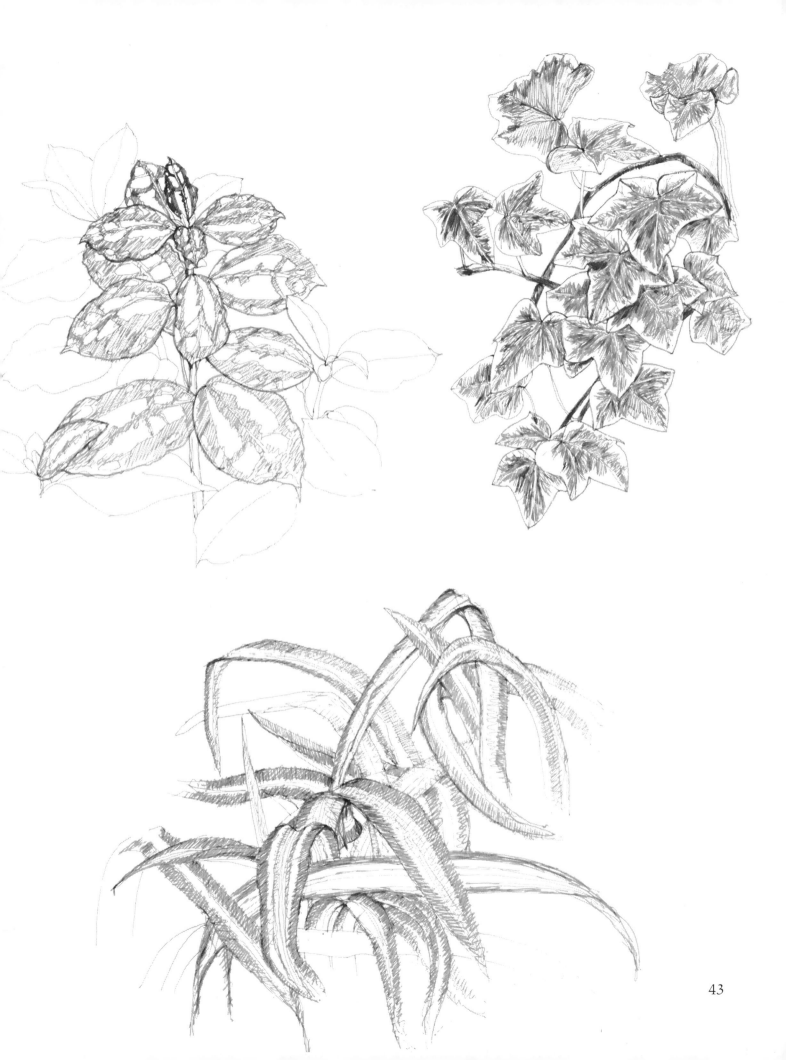

Patterns and designs derived from plants: 1

Plants can provide marvellous reference material for patterns and designs. Look carefully at a plant or a part of a plant for inspiration. Repeating a shape that you see, or varying it by shading or by reversing it, can build up imaginative patterns.

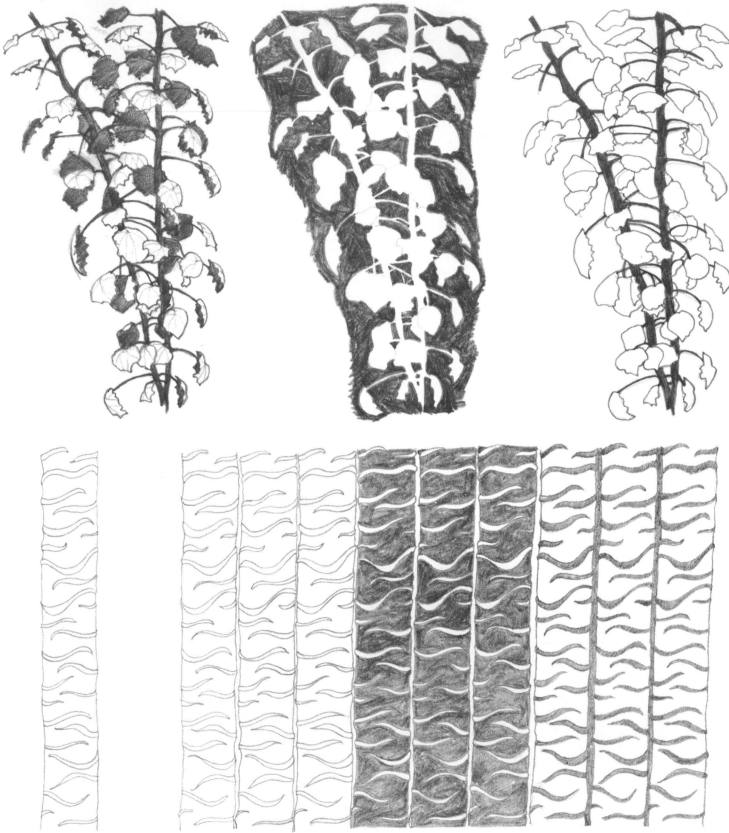

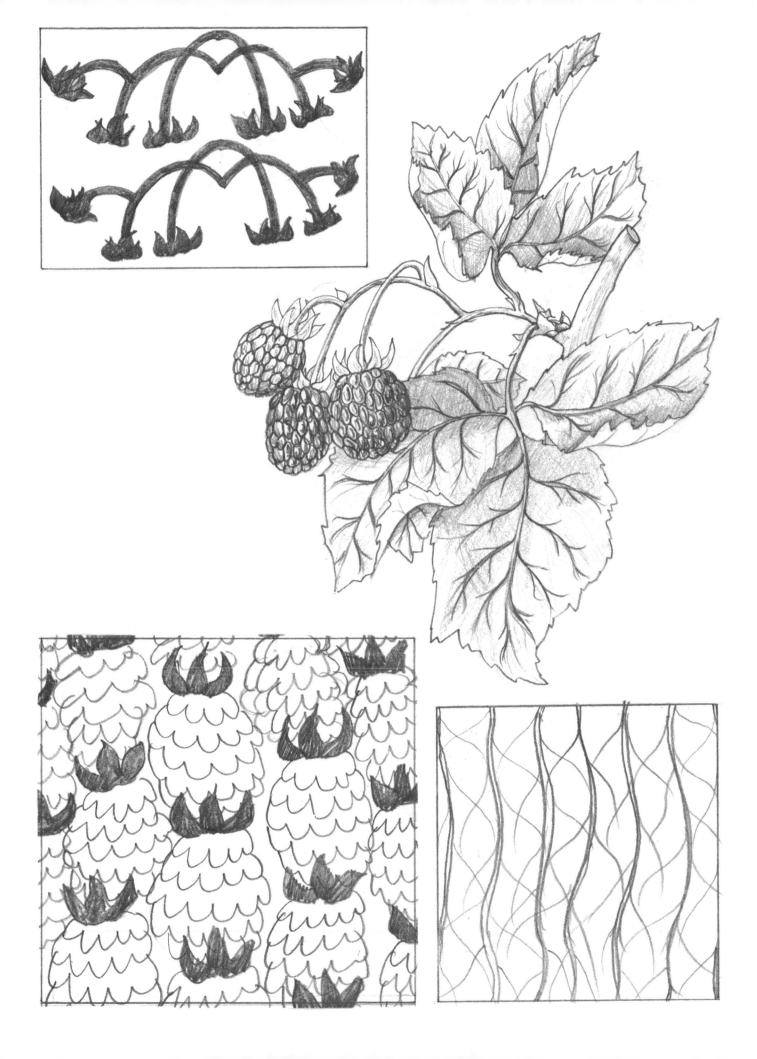

Patterns and designs derived from plants: 2

Try collecting a page of patterns drawn directly from plants and then use them to make a design. This could be for a piece of embroidery, a book mark or to decorate the borders of a card.

All the shapes in the design opposite have been taken from the drawings of plants on this page.

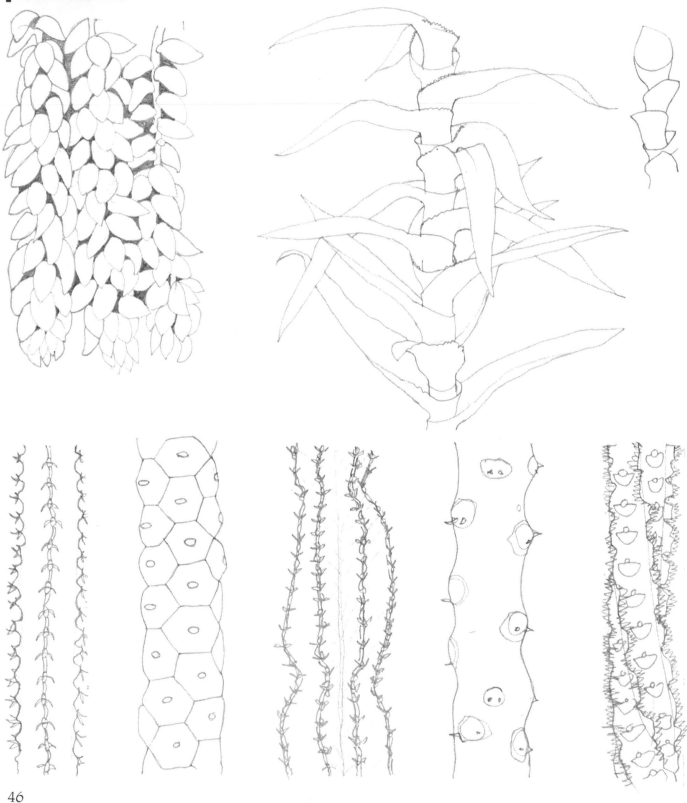

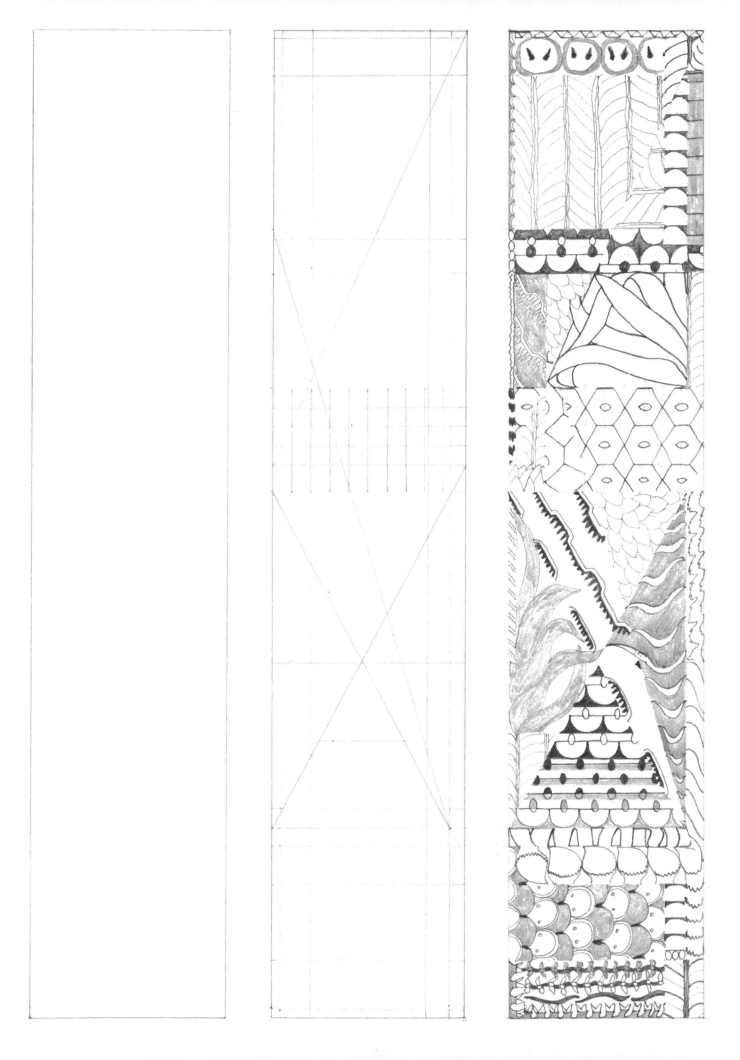